best bear ever!

a little year of

liz climo

RUNNING PRESS
PHILADELPHIA

Running Press
Hachette Book Group
1290 Avenue of the Americas, New York, NY 10104
www.runningpress.com
@Running_Press

Printed in China

First Edition: September 2018

Published by Running Press, an imprint of Perseus Books, LLC,
a subsidiary of Hachette Book Group, Inc. The Running Press name
and logo is a trademark of the Hachette Book Group.

The Hachette Speakers Bureau provides a wide range of authors for speaking events.
To find out more, go to www.hachettespeakersbureau.com or call (866) 376-6591.

The publisher is not responsible for websites (or their content)
that are not owned by the publisher.

Print book cover and interior design by Ashley Todd.

Library of Congress Control Number: 2018931943

ISBNs: 978-0-7624-6362-6 (hardcover), 978-0-7624-6363-3 (ebook)

LREX

10 9 8 7 6 5 4 3 2 1

for louie and guillaume

introduction

Hello! Welcome to the best year ever, where everything is fun, nothing is too sad, and everyone gets along with everyone else—just like in real life!

Since sarcasm is sometimes difficult to detect in text, and chances are you're about to give up on this intro anyhow (do people read intros?), let me cut to the chase—this book is meant to make you happy and to take your mind off the heaviness of real life, because life can be a real bummer sometimes. This book is meant to make you laugh, and hopefully, it does.

I started doing these comics about seven years ago, when I was still relatively new to social media. There was no grand purpose for them—just a way for me to tell some jokes and force myself to draw something other than *The Simpsons* (the show I was working on as an animator at the time). I credit the broad reach of social media for much of the success that the comics have had, and I am eternally grateful to Tumblr for being straightforward enough that even I could figure out how to use it. (I'm not exactly tech-savvy. Sometimes I open the calculator on my iPhone and try to call people with it.) But as grateful as I am to social media for helping these comics get exposure, it is also a very scary place: the trolls, the constant fighting, the daily reminders of how horrible the world can be. It can all be heavy.

Though social media terrified me a little, I continued posting comics (sometimes hiding behind the couch afterward, as if it might shield me from the negative feedback). Eventually, I started getting messages from people who were going through a hard time. They'd tell me that the comics provided a bit of comfort or distraction in the midst of their sadness, and I felt (still feel) incredibly humbled every time I'd receive one of these messages. I've been through these terrible periods of hopelessness—we all have. It's really nice to know these comics could provide even just a little bit of a distraction.

This book is dedicated to two people I knew through social media (although I never had the pleasure of meeting them in person), Louie and Guillaume. They left this world far too soon, but they clearly left an enduring impression on everyone who was lucky enough to know them. I think about them often, and they remind me that even in darkness there can be a little bit of light, and that life is too precious to not at least try to be good to one another.

Hopefully, this book inspires you to see the good, or at least cheers you up a bit. Or, maybe you'll think it's dumb and throw it across the room because you're in a really bad mood today. That's fine, too! Just please buy it first, and don't throw it in the bookstore, because they really don't like that. And if things have been extra hard for you lately, I hope that, starting today, you have the best year ever.

Liz Climo

spring

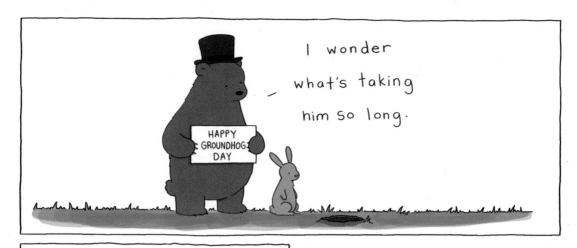

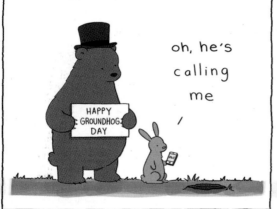

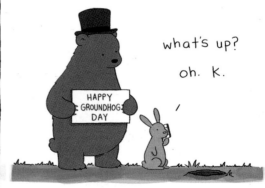

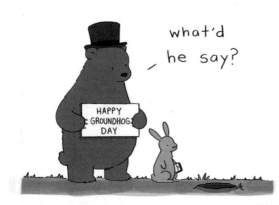

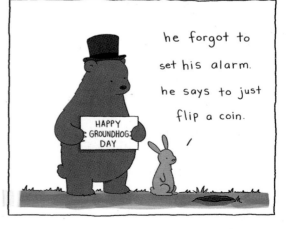

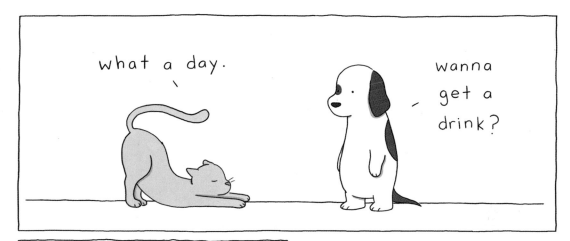

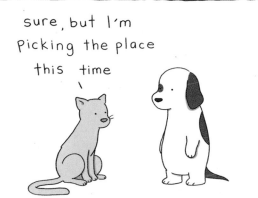

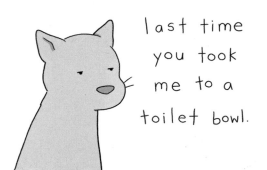

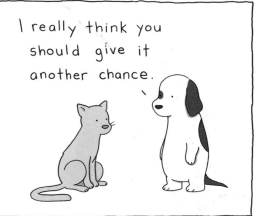

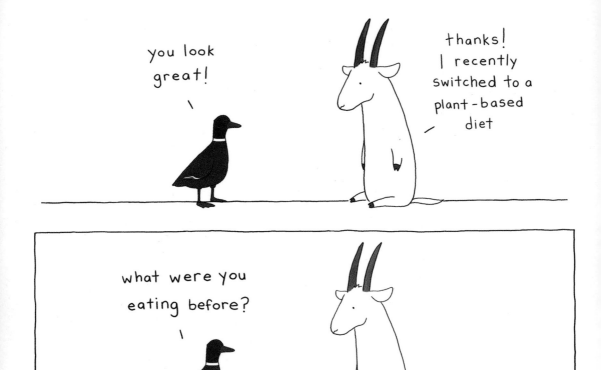

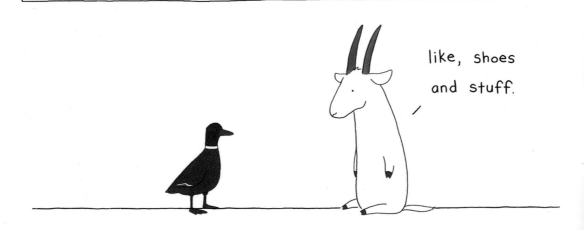

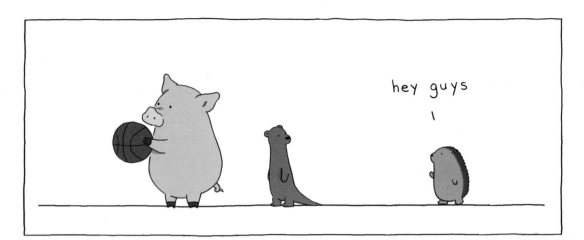

hey guys

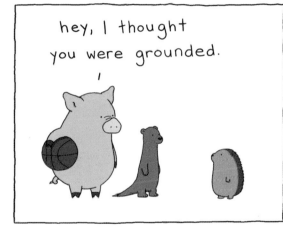

hey, I thought you were grounded.

I am..

won't your mom be mad?

I left a rolled up brown sock on my bed. she'll just think I'm sleeping

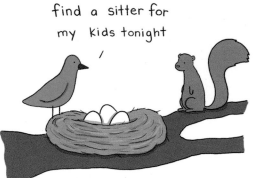

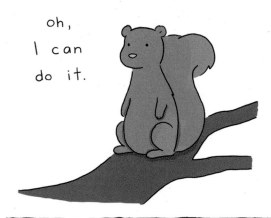

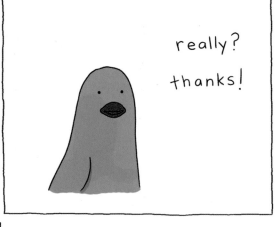

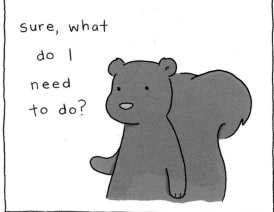

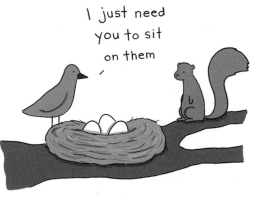

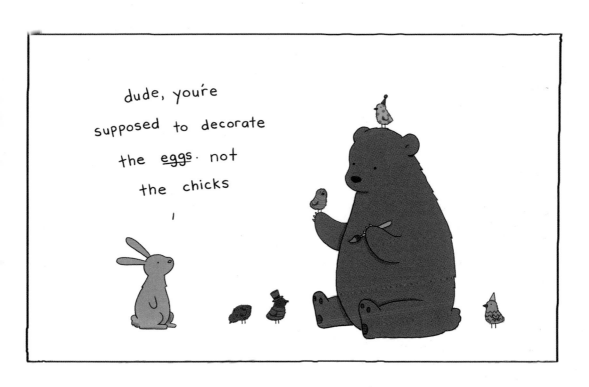

dude, you're supposed to decorate the ~~eggs~~. not the chicks

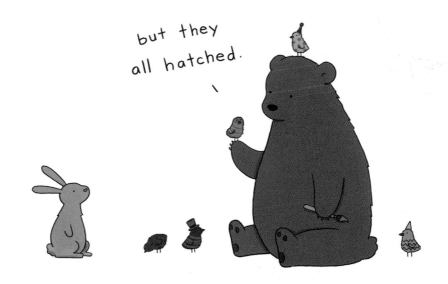

but they all hatched.

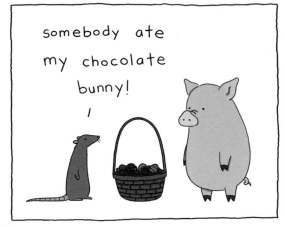

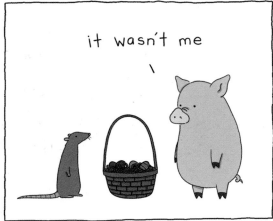

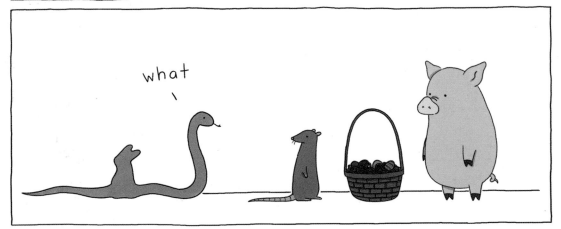

good morning!

I made eggs.

why are they brown?

I used chocolate eggs left over from Easter.

fresh fruit?

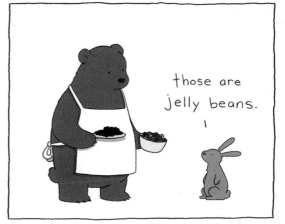

those are jelly beans.

I noticed a bunch
of new plants out back
that nobody's eaten yet.

wanna go check
it out sometime?

I can't. I'm
booked the next
couple weeks

oh wow. what
are you doing?

turning into
a butterfly

aah, I love this time of year.

all the leaves are turning brown.

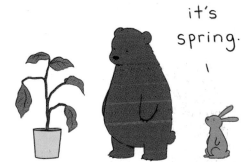
it's spring.

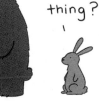
when's the last time you watered that thing?

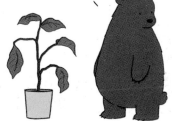
Plants drink water?

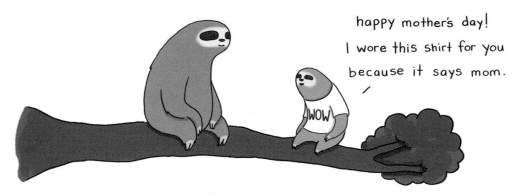

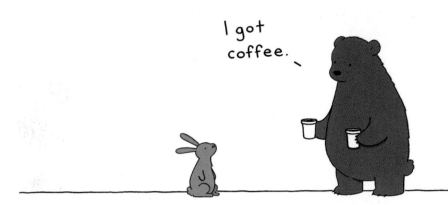

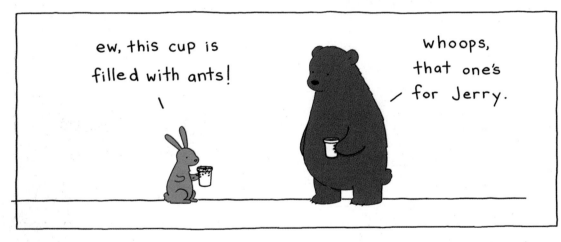

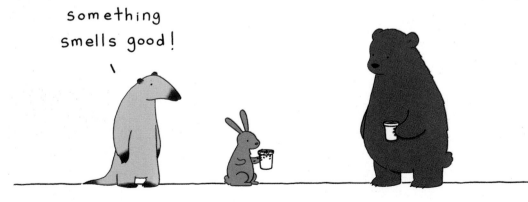

well, that's a tough pillow to swallow.

you mean "pill"

the expression is "that's a tough pill to swallow"

pill? really? but those are so small.

you think a pill is hard, try swallowing a pillow.

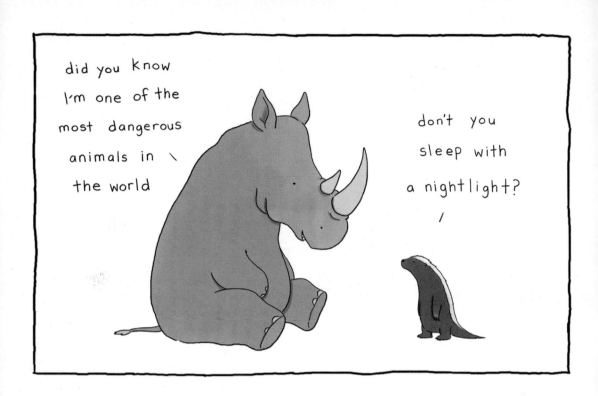

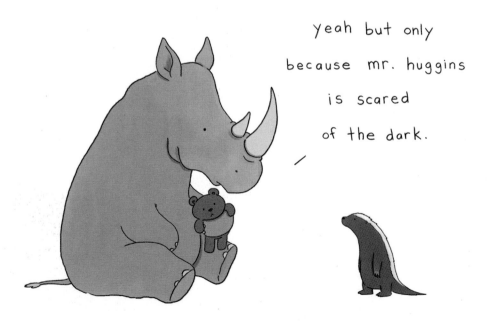

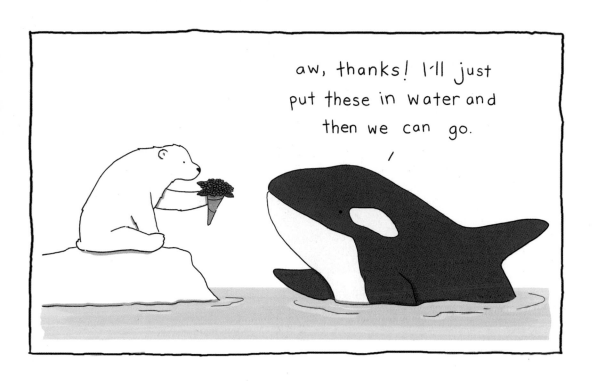

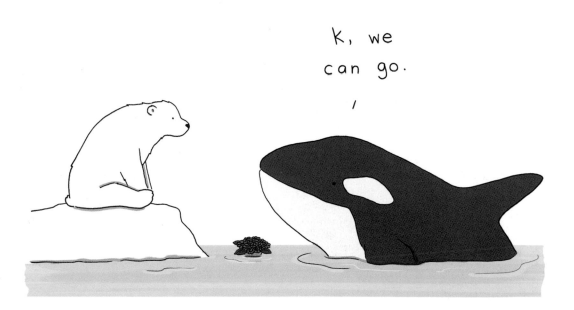

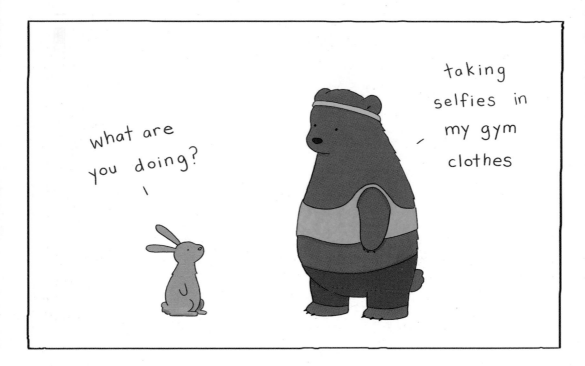

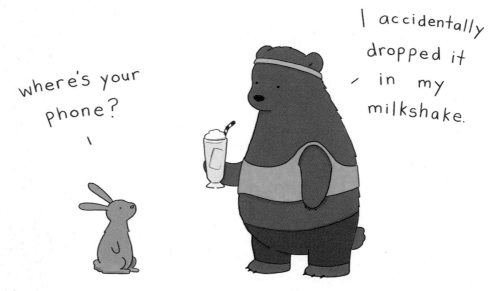

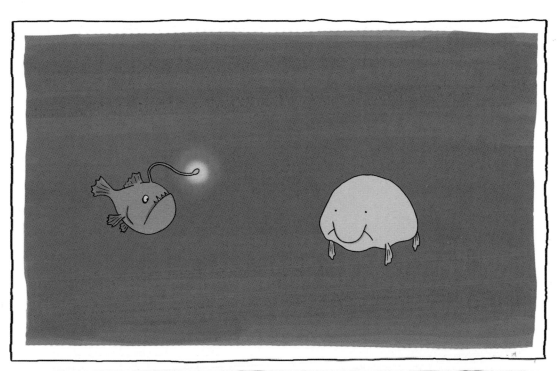

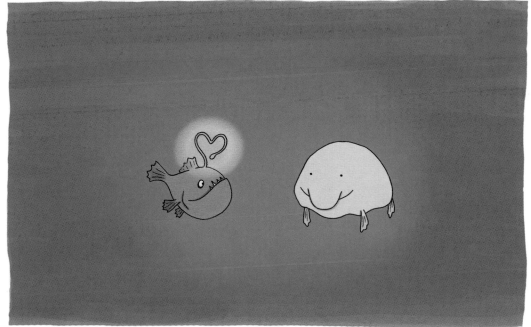

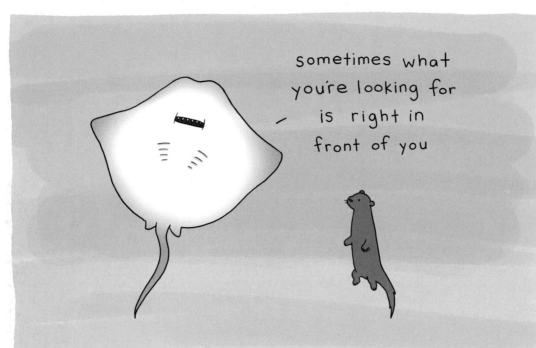

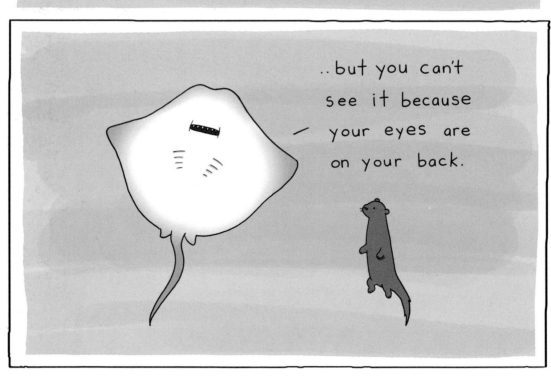

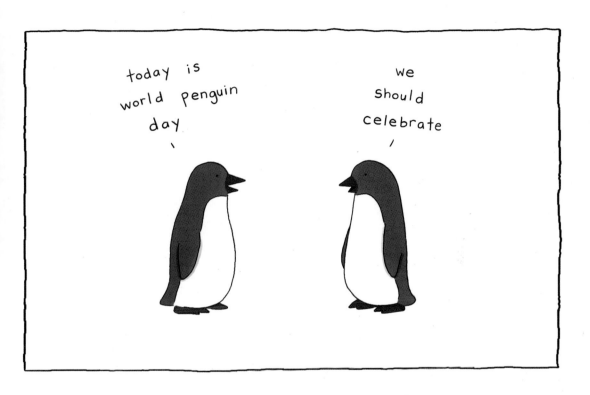

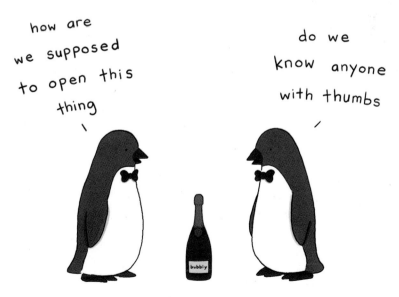

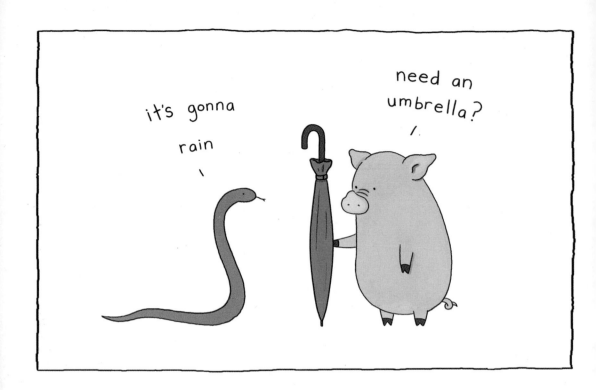

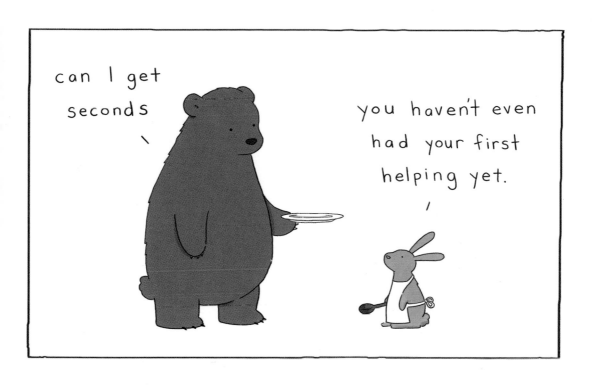

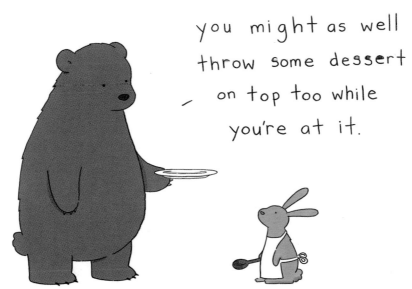

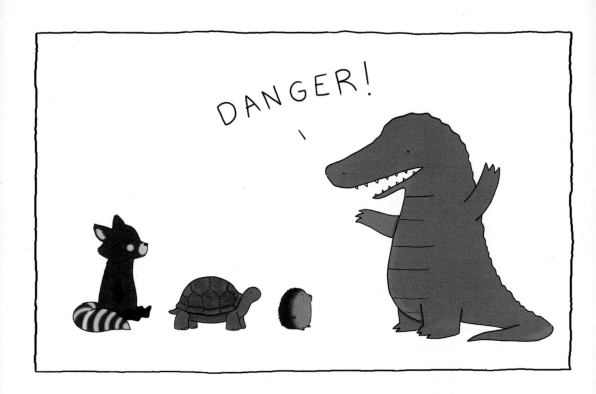

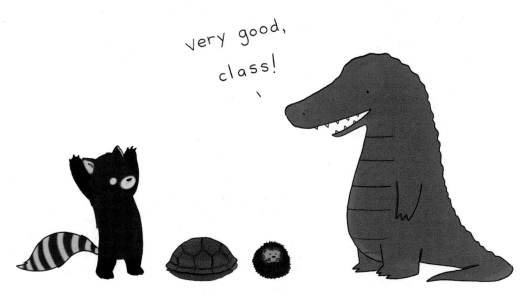

summer

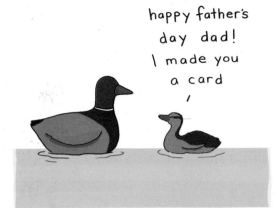

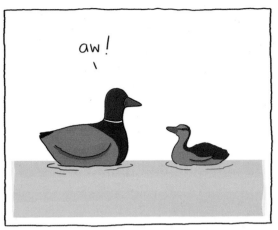

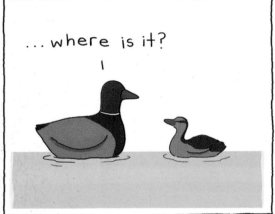

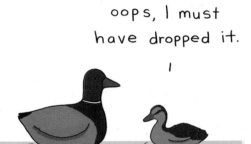

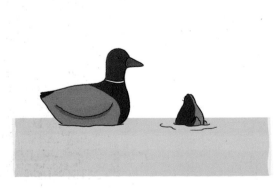

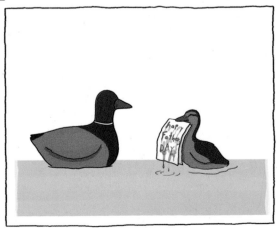

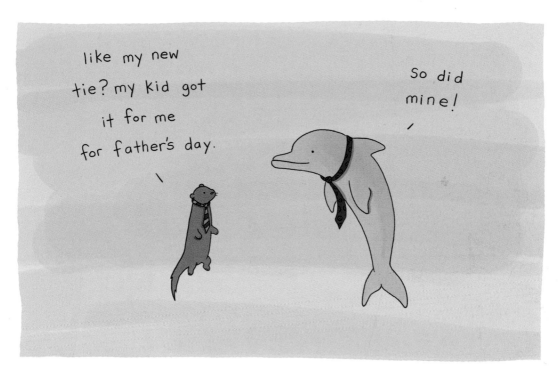

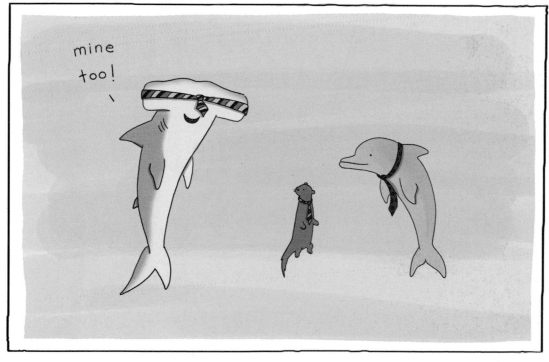

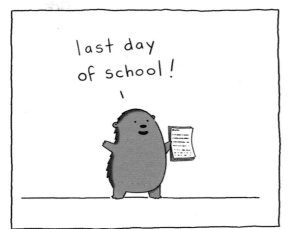

last day
of school!

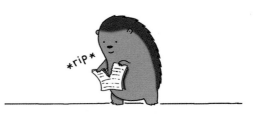

rip

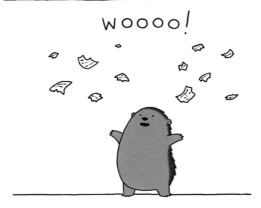

woooo!

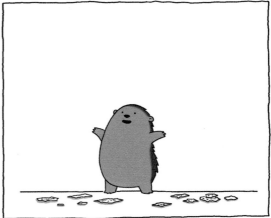

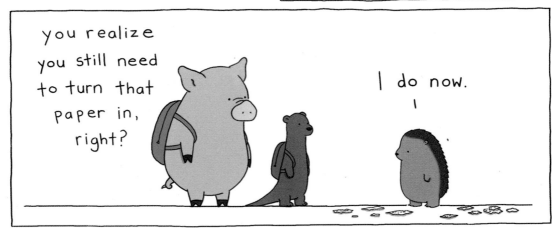

you realize
you still need
to turn that
paper in,
right?

I do now.

It was a dark
and spooky night.
suddenly...

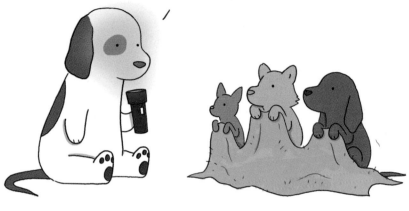

A FIREWORK
GOES OFF!

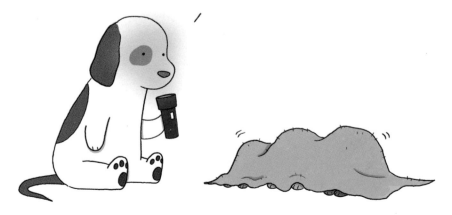

ready to hit
the beach?

not quite,
I'm not really
"summer ready"
if you know
what I mean.

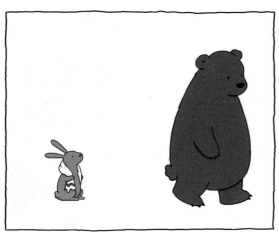

k. let's
roll.

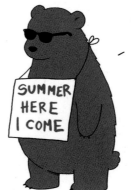

SUMMER
HERE
I COME

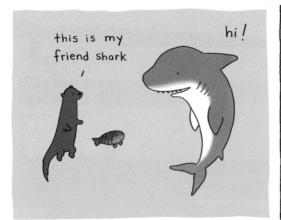

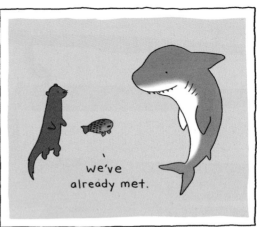

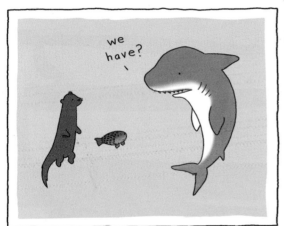

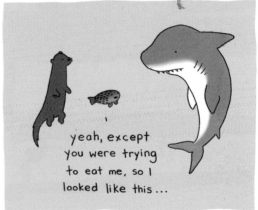

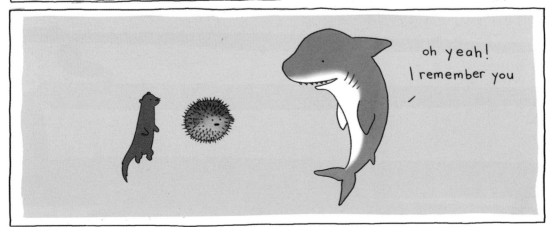

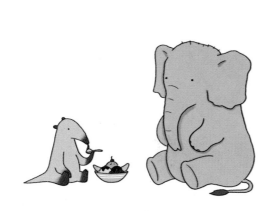
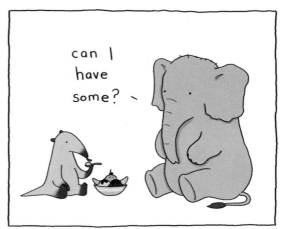
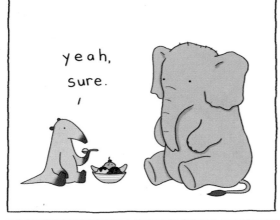
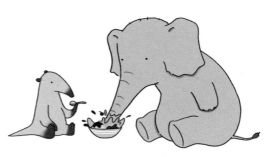
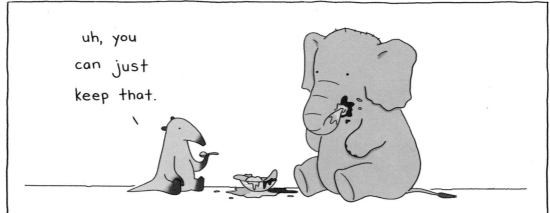

happy summer
solstice! It's the
longest day of
the year.

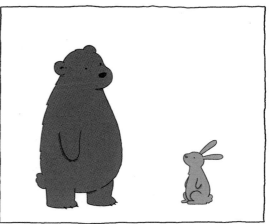

yawn

what time
is it?

it's 4 pm.

I'm going to
bed. let me know
how it ends.

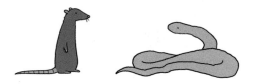

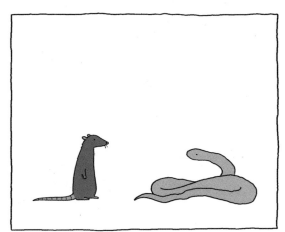

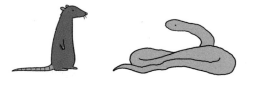

my friend says
if you wanna look
cool, you should
wear sunglasses

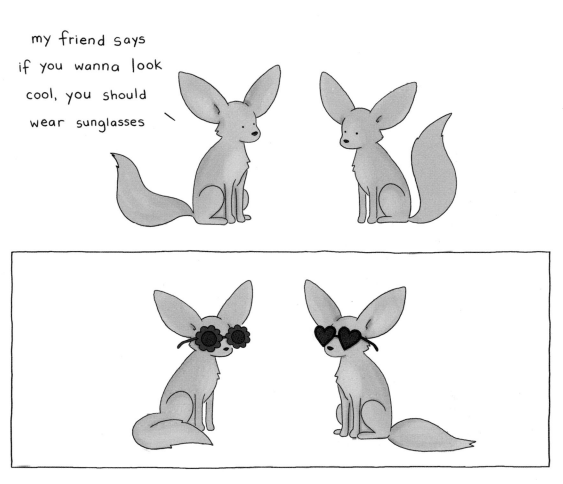

I think
it's
working

me too.

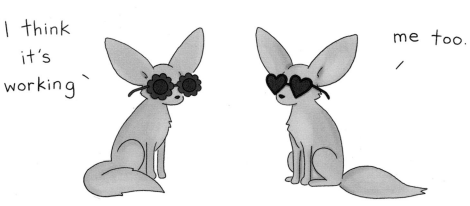

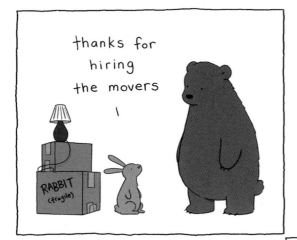

my allergies
are terrible
right now.

want a
tissue?

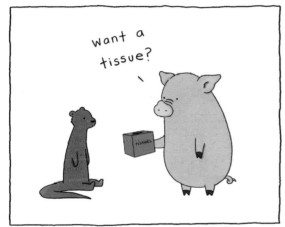

the box
is empty.

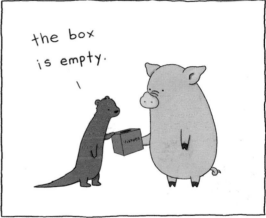

is that
helping?

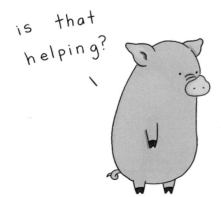

I think
it might
be, actually.

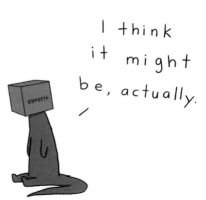

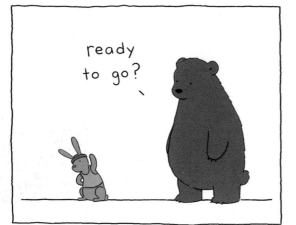

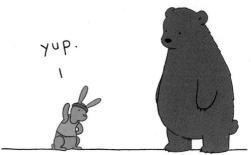

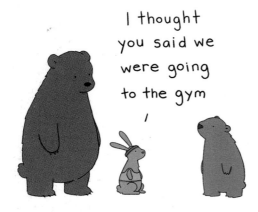

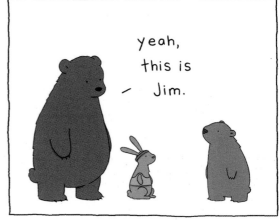

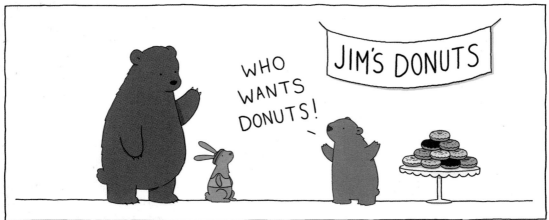

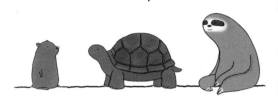

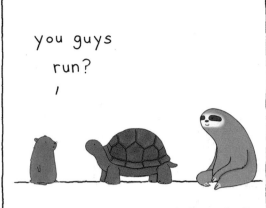

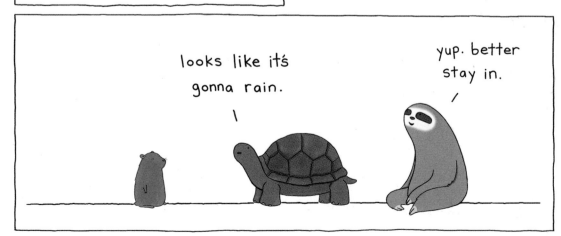

47

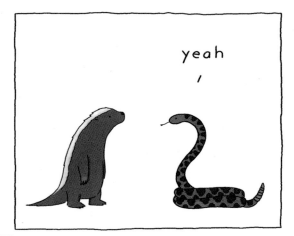

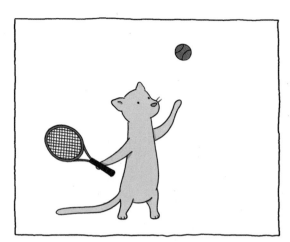

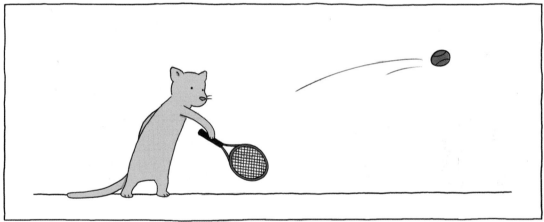

for the
last time –
you don't have
to bring
the ball
back.

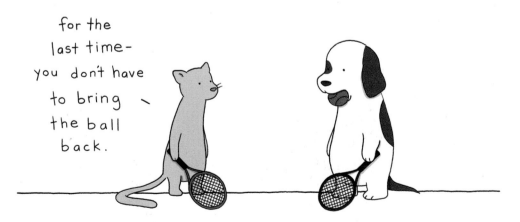

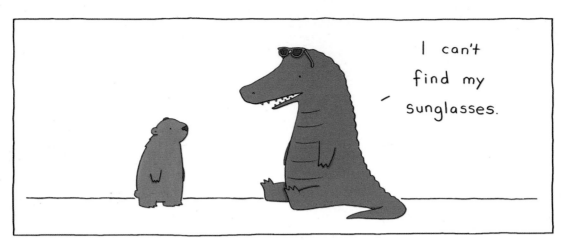

I can't
find my
sunglasses.

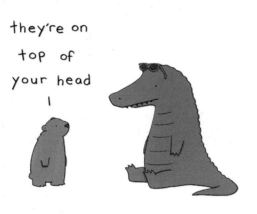

they're on
top of
your head
|

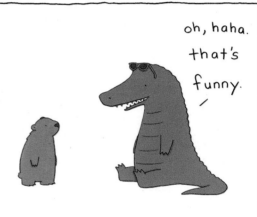

oh, haha.
that's
funny.

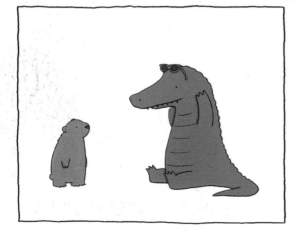

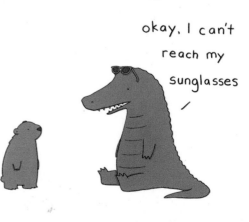

okay, I can't
reach my
sunglasses

so, what
do you think
I should do?

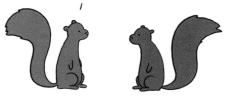

I'm gonna
go out on
a limb here...

this is
my thinking -
limb.

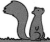

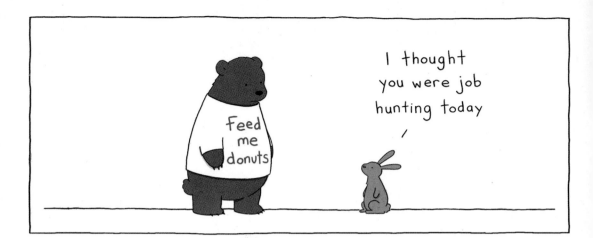

I thought
you were job
hunting today

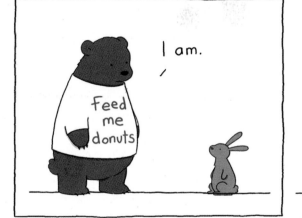

I am.

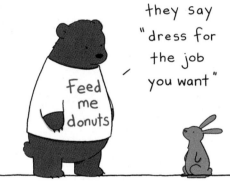

they say
"dress for
the job
you want"

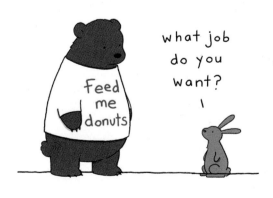

what job
do you
want?

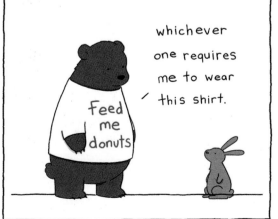

whichever
one requires
me to wear
this shirt.

What a nice
day. I think I'll
go for a walk.

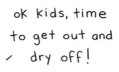

ok kids, time
to get out and
dry off!

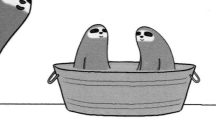

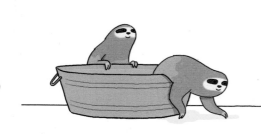

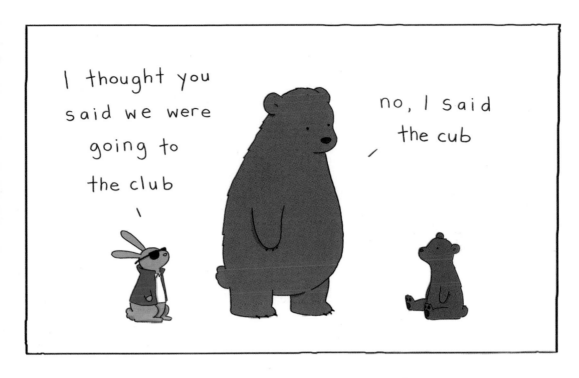

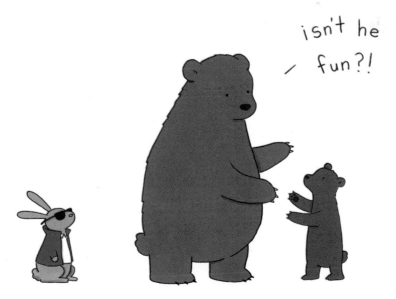

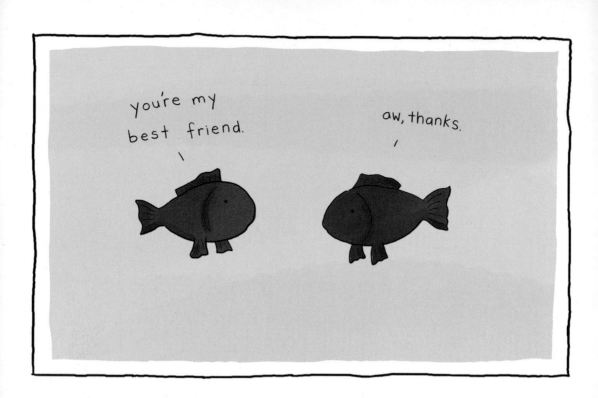

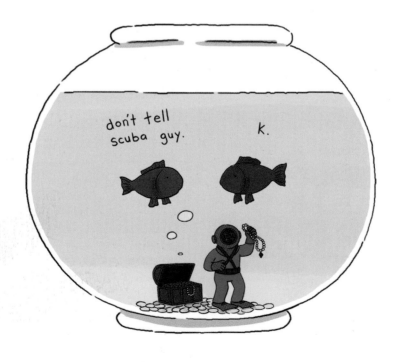

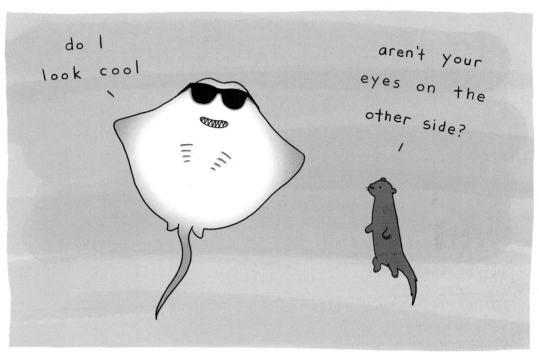

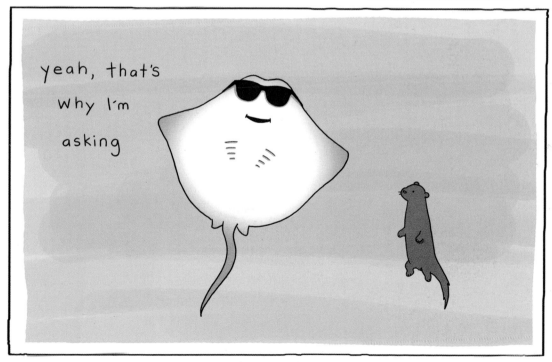

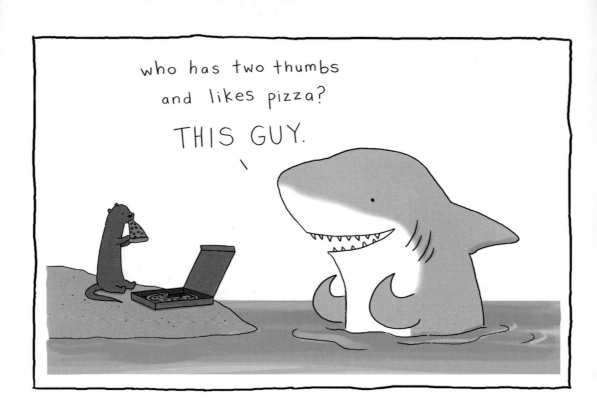

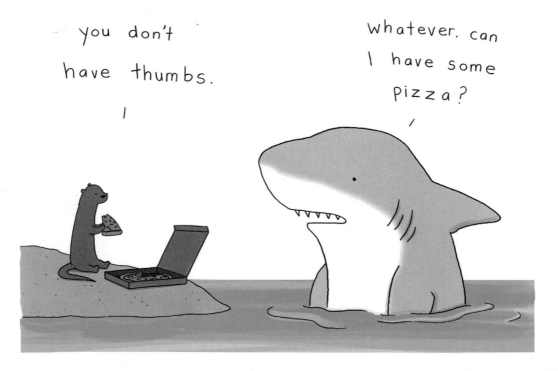

fall

all the stores
are having back
to school sales!

what do
you think
of my
new jeans?

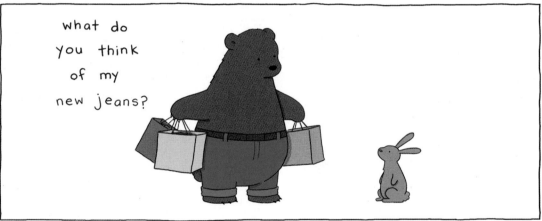

I think
you look like
smokey bear.

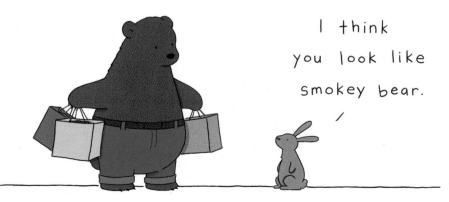

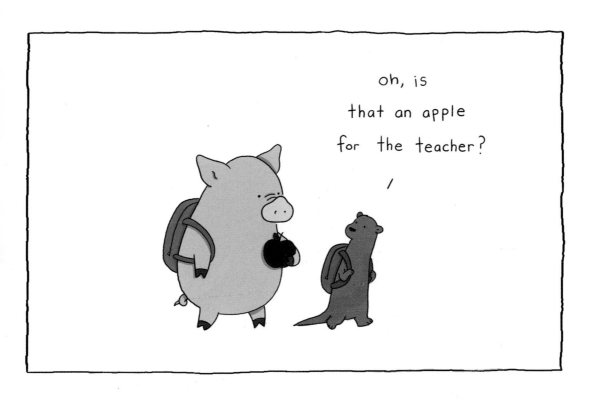

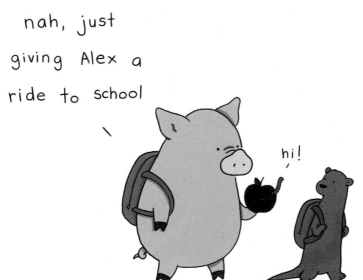

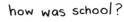

how was school?

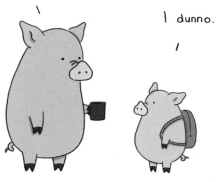

I dunno.

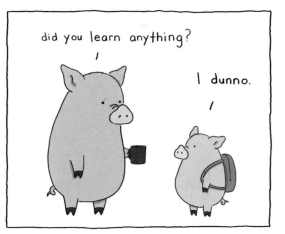

did you learn anything?

I dunno.

well, what's your teacher like?

I dunno.

did you make new friends?

I dunno.

well if there's nothing to report, you may as well start your homewor...

THE DAY BEGAN MUCH LIKE ANY OTHER...

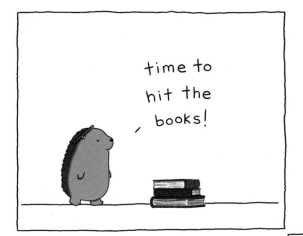

time to
hit the
books!

let's see...
hmm...

gosh,
there's
a lot
of stuff
in
here.

geez.

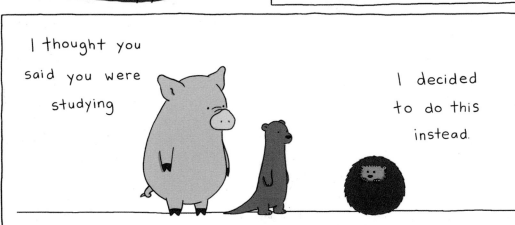

I thought you
said you were
studying

I decided
to do this
instead.

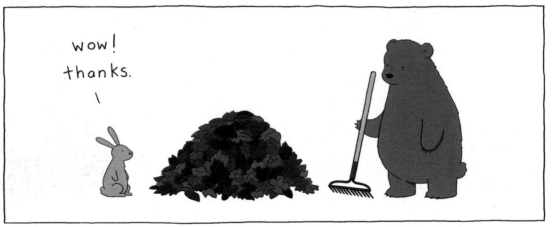

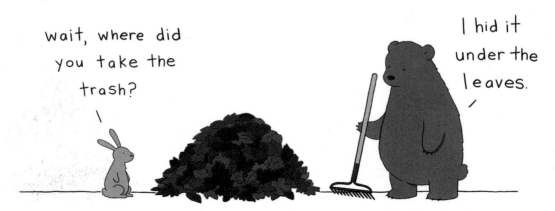

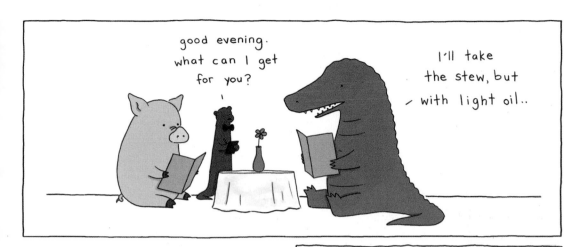

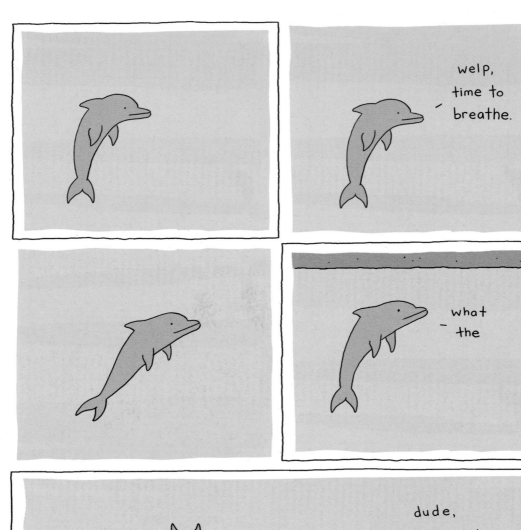

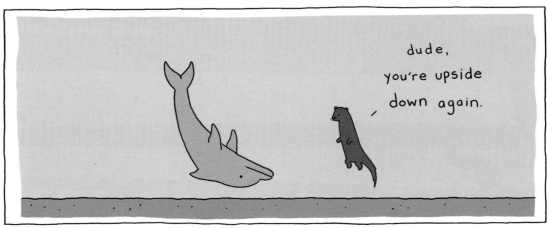

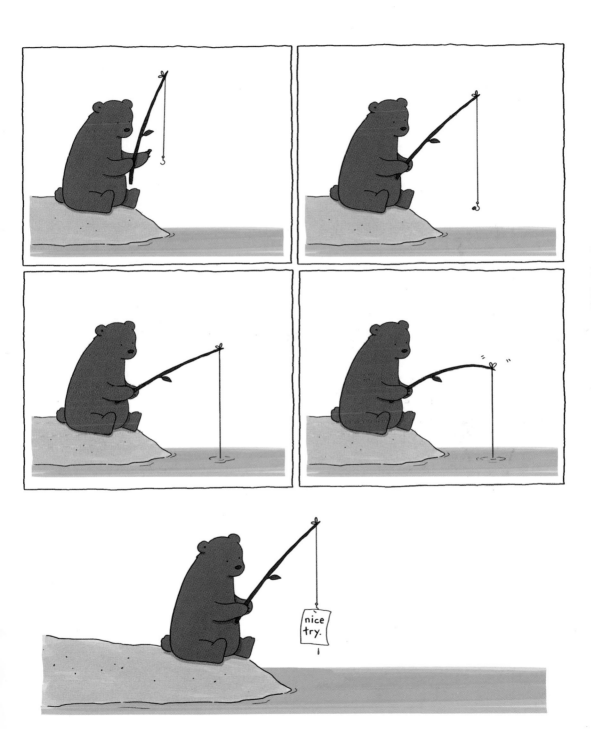

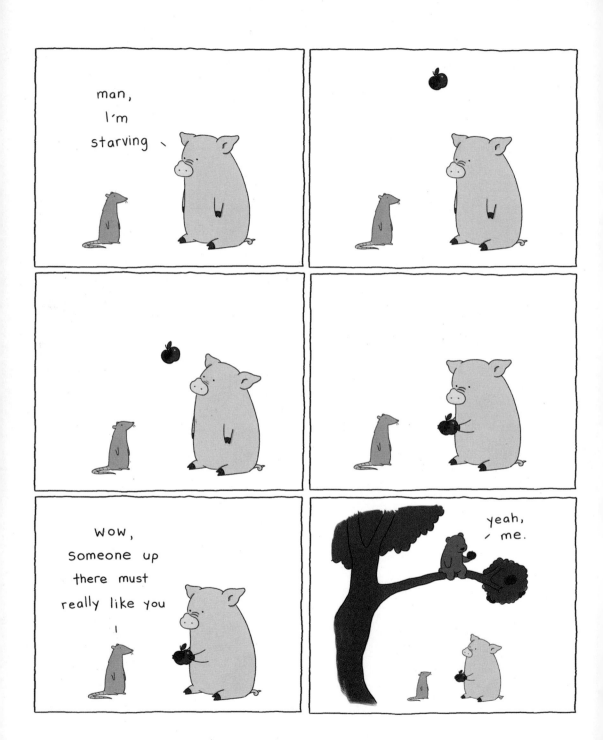

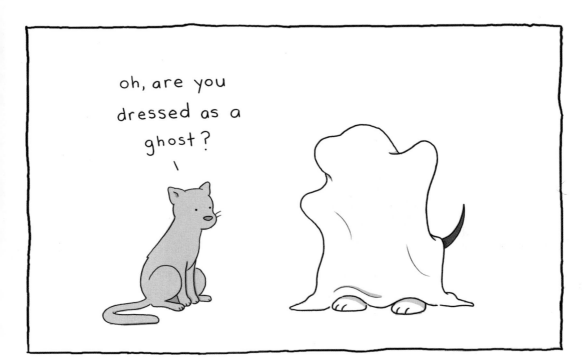

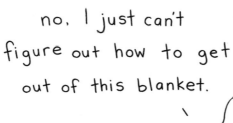

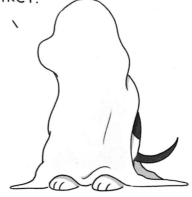

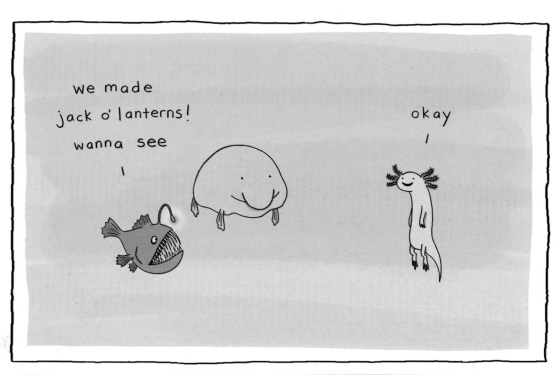

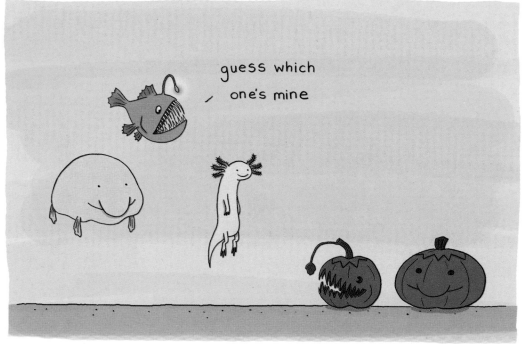

time to put
the halloween
candy out.

I don't
think
we
should.

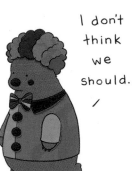

it's just...
halloween
is about
so much
more than
candy...

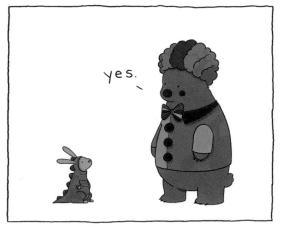

and kids
should
learn that
there are
no handouts.
nothing in
life is free.

you ate
all the
candy,
didn't you?

yes.

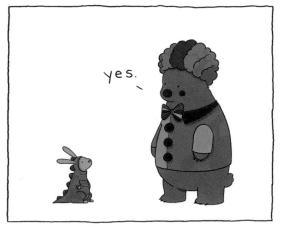

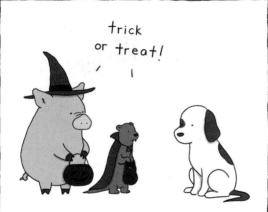

trick
or treat!

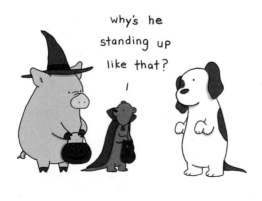

why's he
standing up
like that?

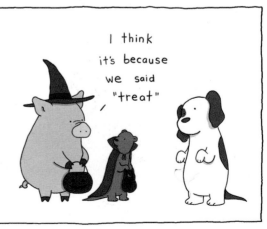

I think
it's because
we said
"treat"

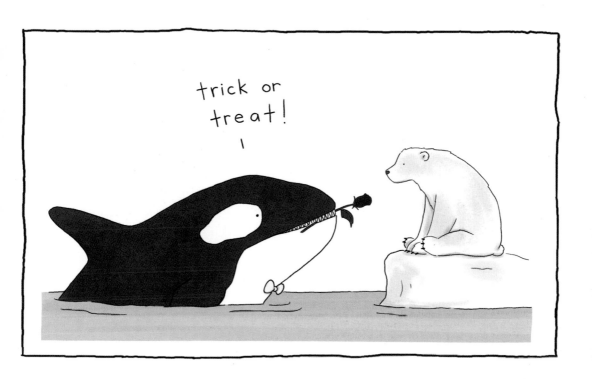

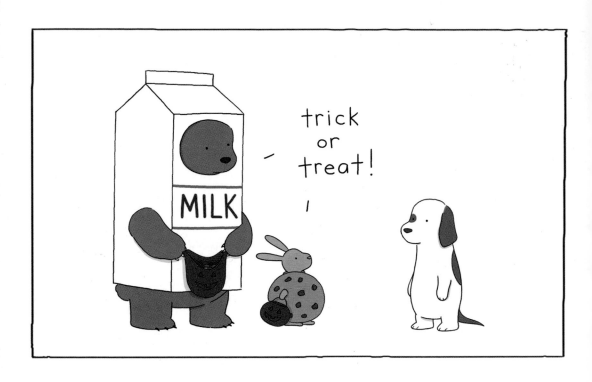

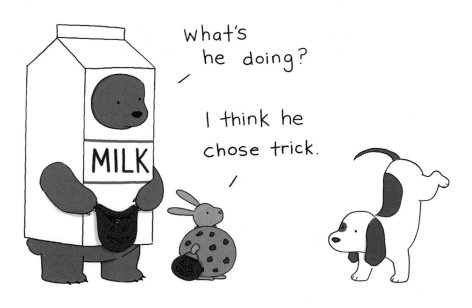

you look
like you could
use a hug.

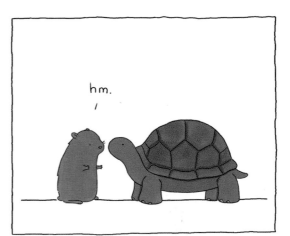

hm.

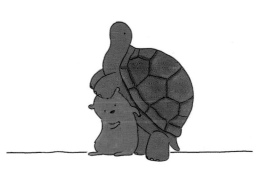

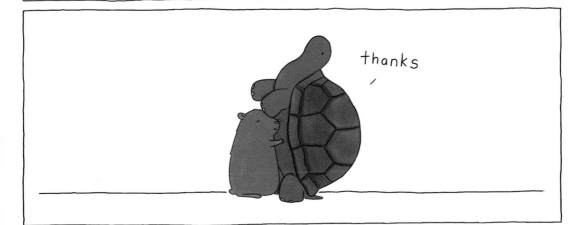

thanks

what do you
want for dinner
tonight?

hmm

I need
my thinking
cap

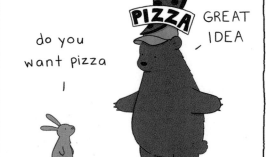
do you
want pizza

GREAT
IDEA

if it looks
like a duck..

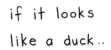

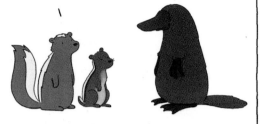

..walks like
a duck..

..and quacks like
a duck, it just
might be a duck.

quack.

he checks
out.

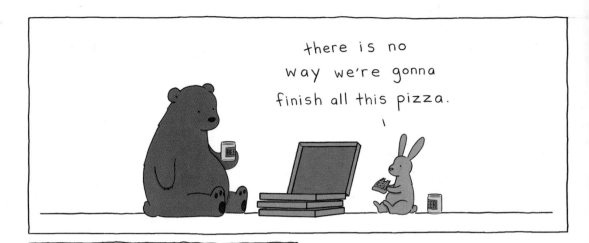

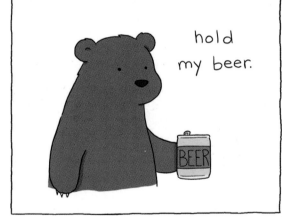

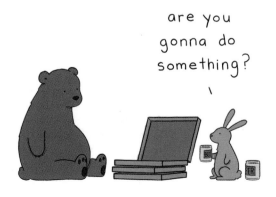

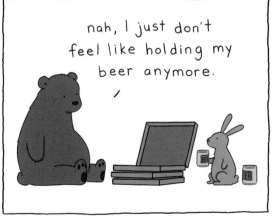

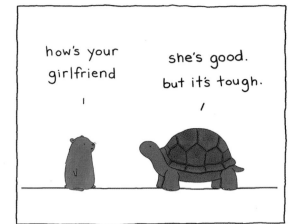

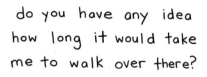

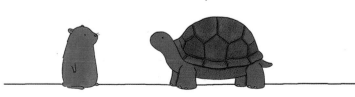

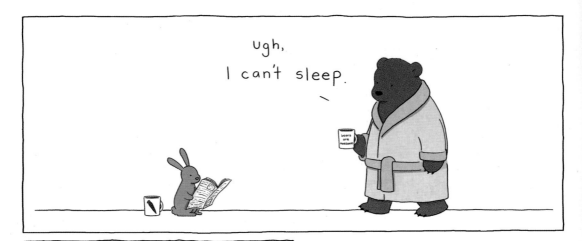

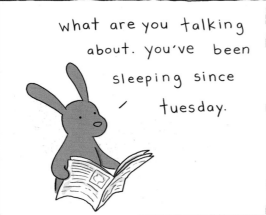

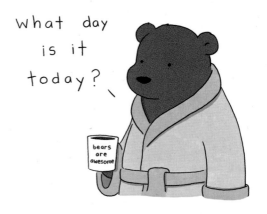

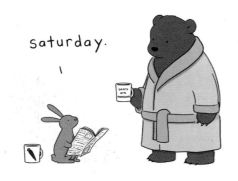

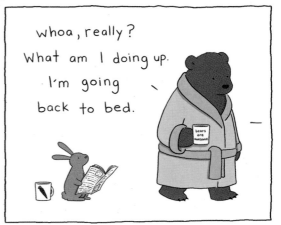

cornucopia:
an abundant
supply of good
things of a
specified
kind.

what do you think?

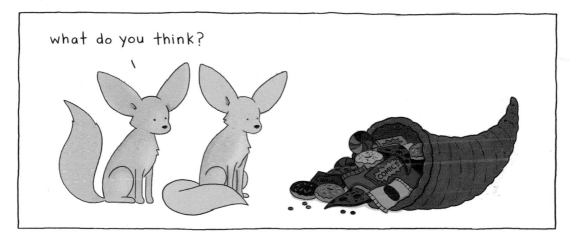

needs more donuts.

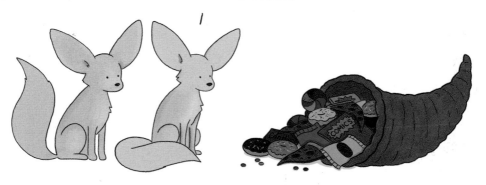

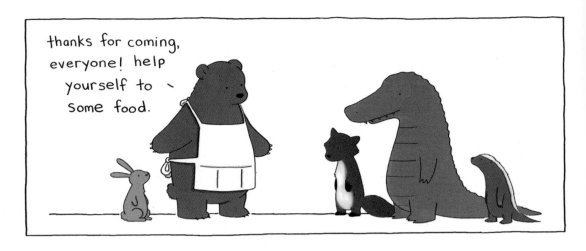

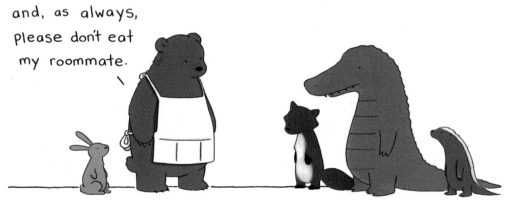

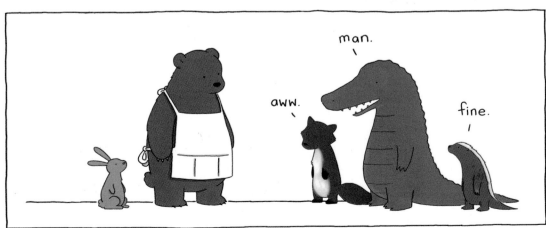

winter

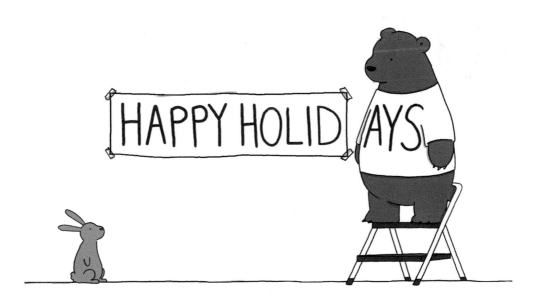

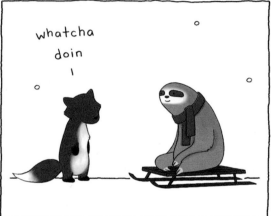

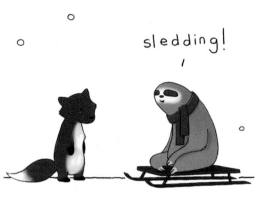

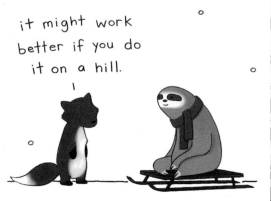

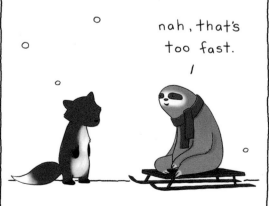

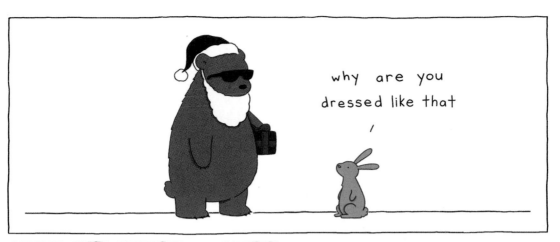

why are you
dressed like that

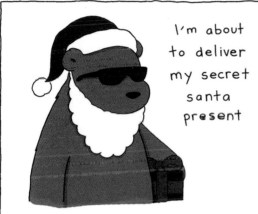

I'm about
to deliver
my secret
santa
present

isn't that
supposed
to be a
secret gift
exchange?

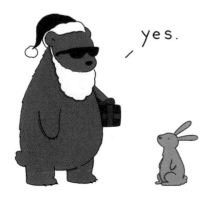

yes.

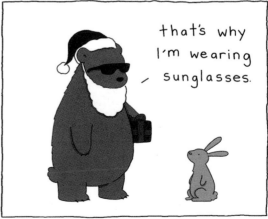

that's why
I'm wearing
sunglasses.

ready for
the holiday
party? \

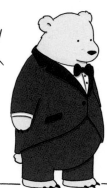

shoot! I didn't
know we were
supposed to
/ dress up.

quick, lemme
borrow your tie.
/

my my,
don't you two
look nice.
\

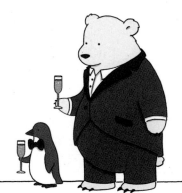

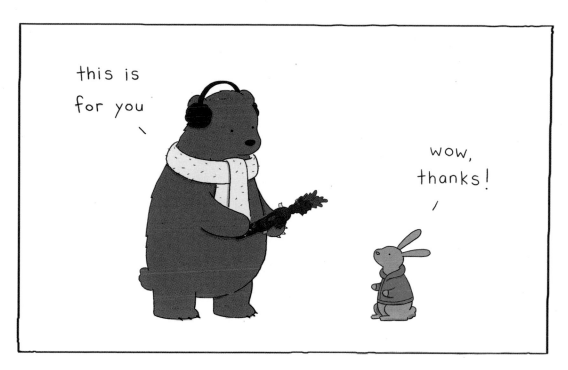

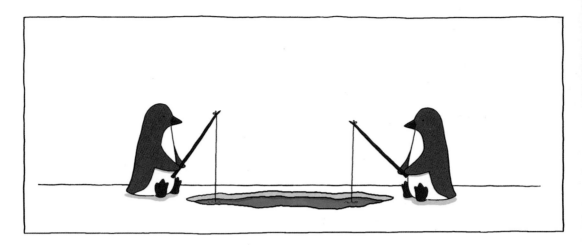

SURPRISE!
haha.

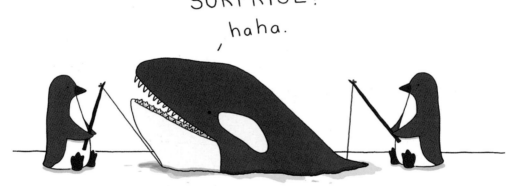

I think
I'm stuck.

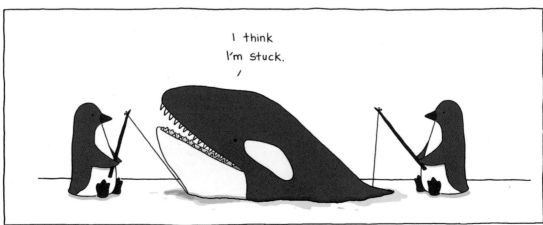

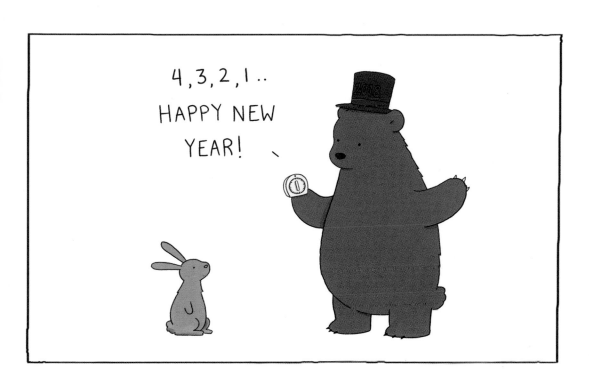

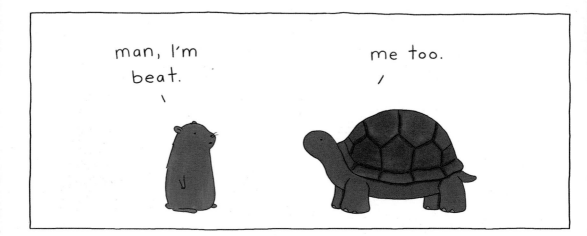

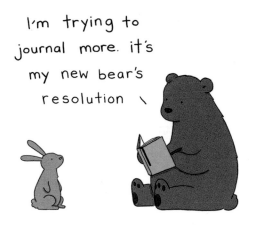

I'm trying to
journal more. it's
my new bear's
resolution \

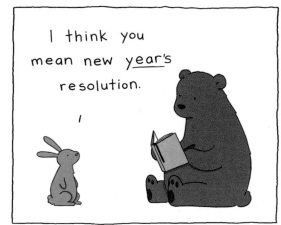

I think you
mean new y<u>ear's</u>
resolution.

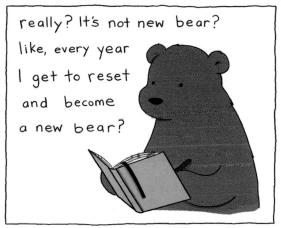

really? It's not new bear?
like, every year
I get to reset
and become
a new bear?

no.
/

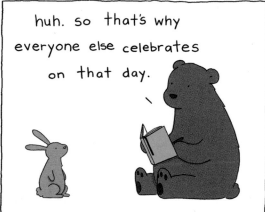

huh. so that's why
everyone else celebrates
on that day.

it's january.
I thought
bears hibernated
in the winter

everyone
thinks that,
but not all
of us do.

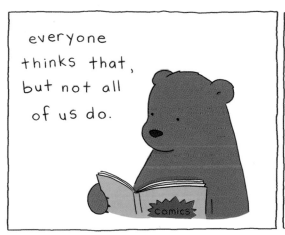

Some of us just
slow down a bit,
take a lot of
naps, watch a
lot of tv, etc.

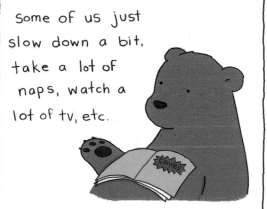

sounds like it's
just an excuse to be
lazy for a few months.

look,
I don't
make the
rules.

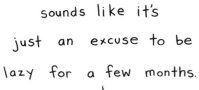

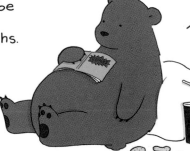

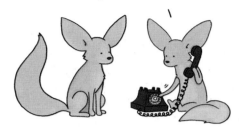

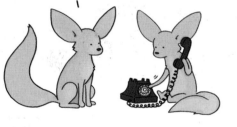

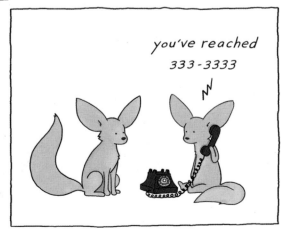

are you still
upset about the
holidays being over

I hate this
time of year.
/

well, it's dinner
time. what do you
want to eat

my feelings.
/

okay.
extra cheese?

yes
Please.
/

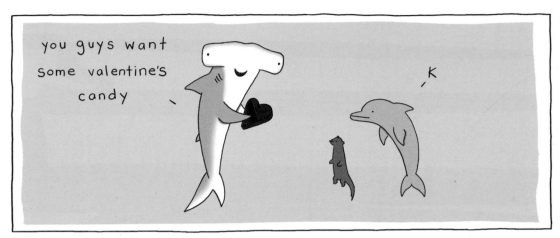

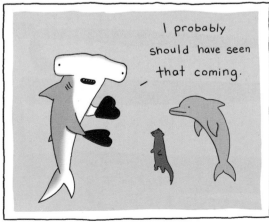

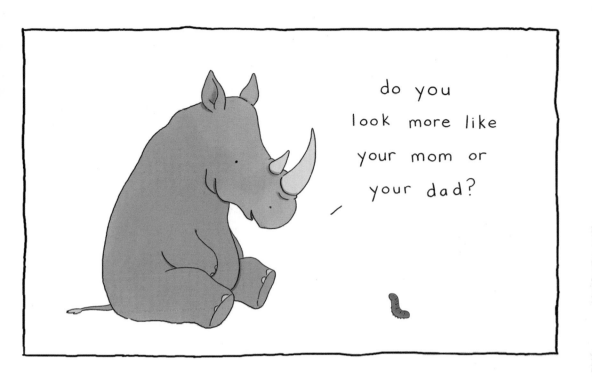

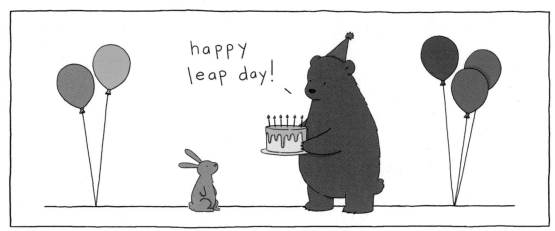

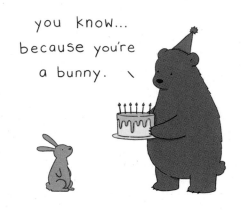

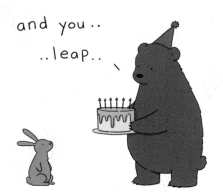

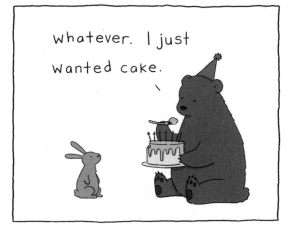

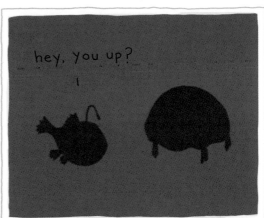

hey, you up?

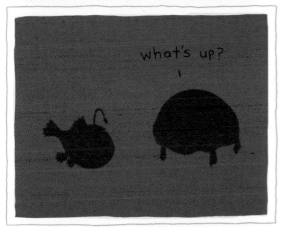

what's up?

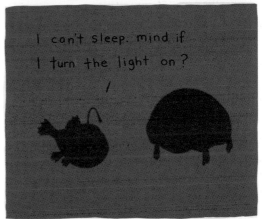

I can't sleep. mind if
I turn the light on?

go for it.

hey, will you do me a favor?

sure thing

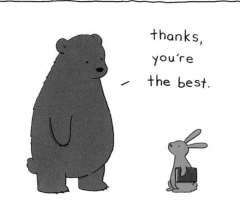
thanks, you're the best.

hey, wanna come to a magic show?

is that the favor?

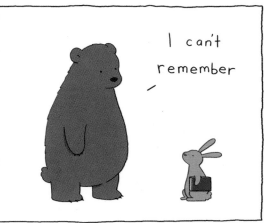
I can't remember

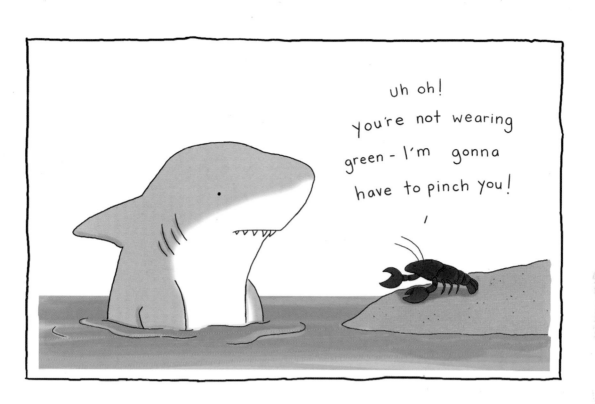

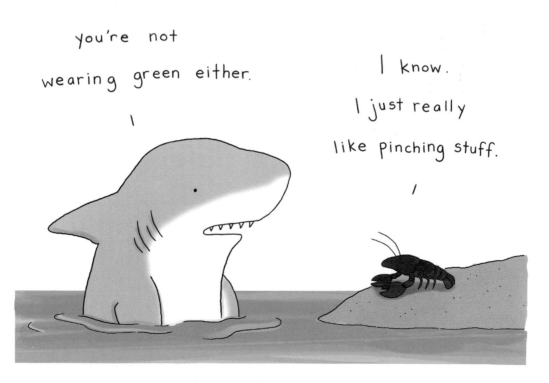

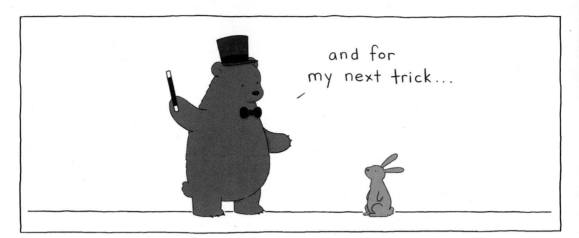

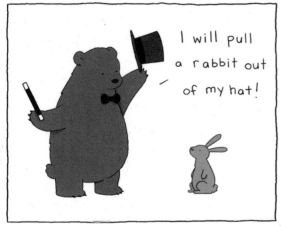

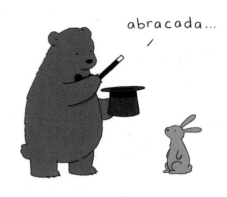

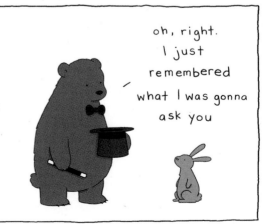

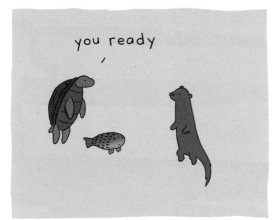

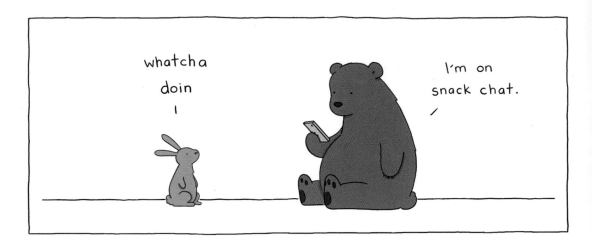

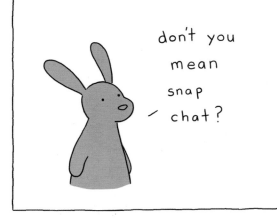

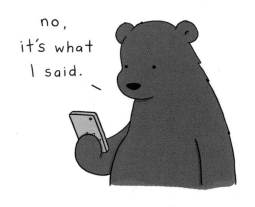

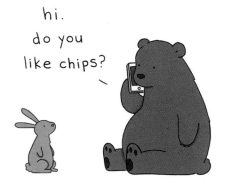

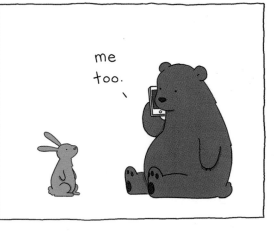

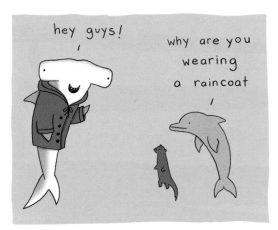

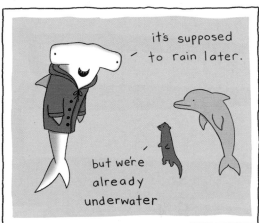

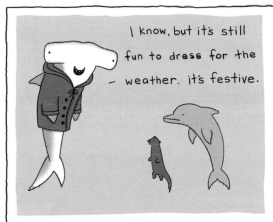

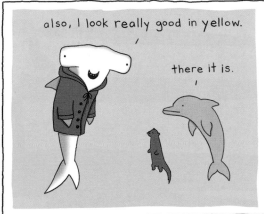

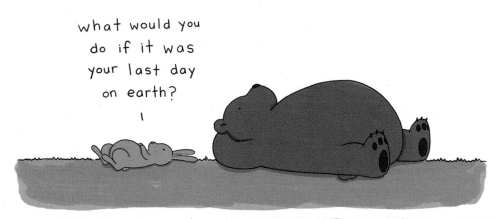

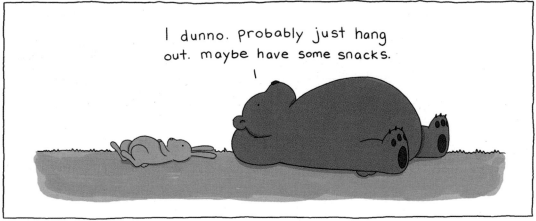

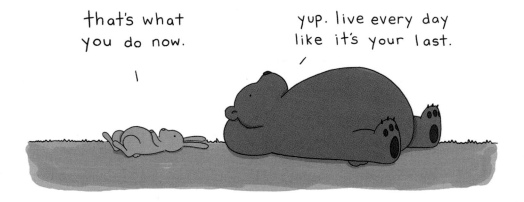

acknowledgments

Thanks to my wonderful agent, Kathleen Ortiz, for working so hard on my behalf. Without her I'd probably still be drawing on napkins at pub trivia night. I also want to thank Pouya Shabazian and the entire New Leaf Literary team for their awesome work. Jennifer Kasius, and the team at Running Press, for beautifully orchestrating this third comic compilation for me (THIRD! How exciting. I can't believe it). My assistant Anne Grasser, who is doing a fantastic job of keeping me sane on a daily basis. My extended family, for their continued love, support, and inspiration. My incredible friends, and all of their adorable children and animals. Colin and Marlow, who laugh at my jokes when they're funny and have no problem telling me when they aren't. I love you both so much. To anyone who has ever enjoyed or continues to enjoy my comics—I am endlessly appreciative of you. Thank you.